What is a Copyright

Fourth Edition

AMERICAN**BAR**ASSOCIATION
Intellectual Property
Law Section

Cover and interior design by ABA Design

Printed in the United States of America.

26 25 24 23 22 5 4 3 2 1

ISBN: 978-1-63905-126-7

Discounts are available for books ordered in bulk. Special consideration is given to state bars, CLE programs, and other bar-related organizations. Inquire at Book Publishing, ABA Publishing, American Bar Association, 321 N. Clark Street, Chicago, Illinois 60654-7598.

www.shopABA.org

Contents

What Is a Copyright?

At its most basic level, a copyright is a property right in an original work of authorship that is fixed in tangible form, such as a writing, image, or recording. The copyright owner—initially, the author or the employer if the work is created within the scope of employment—holds certain exclusive rights in the work, such as the right to reproduce and distribute it and to authorize (license) others to do so.

Source of Copyright Law

The current U.S. Copyright is codified at 17 U.S.C.A. § 101, *et seq.*

The roots of copyright protection extend several centuries to the early days of the printing press. At that time, the British government granted exclusive rights to print certain books. These "royal grants of patents" for printing are the predecessors of modern copyrights.

In the United States, the Constitution gives Congress the authority to create copyright laws. Congress enacted the first federal copyright legislation in 1790, and the copyright laws have been revised several times since then. The current Copyright Act was passed in 1976 and became effective on January 1, 1978.

Congress has continued to amend the Copyright Act to address new copyright issues. In 1988, Congress amended the Copyright Act of 1976 through the Berne Convention Implementation Act (Berne Act). The Berne Act, effective March 1, 1989, modified the United States copyright law to conform further with the standards set out in the Berne Convention, an international copyright treaty the United States joined in 1989. In 1994, Congress passed the Uruguay Round Agreements Act to implement the Agreement on Trade-Related Aspects of Intellectual Property Rights (TRIPS) that, among other things, restored the copyright of certain foreign works that had fallen into the public domain. In 1998, Congress enacted the Sonny Bono Copyright Term Extension Act and the Digital Millennium Copyright Act to implement the WIPO Copyright Treaty and the WIPO Performances and Phonograms Treaty and to address some of the copyright issues associated with the emergence of digital technologies and extended

the term of copyright. Since 1998, the copyright law has been amended more than a half dozen times, including notably the Music Modernization Act in 2018 to make statutory music licensing more fair and efficient and the CASE Act in 2020 to establish a small claims copyright tribunal.

What Can Be Copyrighted?

Requirements

Copyright protection extends to "original works of authorship fixed in any tangible medium of expression." Works of authorship include, but are not limited to: literary works (including computer programs); musical works (including accompanying words); dramatic works (including accompanying music); pantomimes and choreographic works; pictorial, graphic, and sculptural works; motion pictures and other audiovisual works; architectural works; and sound recordings.

To qualify for copyright protection, a work must be "fixed." A work is fixed when it is in a form that is sufficiently "permanent or stable to permit it to be perceived, reproduced, or otherwise communicated for a period of more than transitory duration." Examples of works that are fixed include a novel written in manuscript form, a sculpture, or a sound recording. A work can be fixed digitally, in computer memory, for example.

Another requirement for copyright protection is originality. This is a modest threshold; generally, a work will contain sufficient originality to qualify for copyright protection if it is independently created and contains at least a modicum of creativity.

Things That Cannot Be Copyrighted

Concepts, ideas, methods, and the like are not entitled to copyright protection, regardless of whether they are fixed in tangible form.

Copyright protection does not extend to any "idea, procedure, process, system, method of operation, concept, principle, or discovery, regardless

of the form in which it is described, explained, illustrated, or embodied." Although ideas cannot be protected by copyright, an author's particular expression of that idea may be protected. So, for example, historical or scientific facts are not entitled to copyright protection. But a documentary film would be entitled to copyright protection for the author's specific expression of the subject matter contained in the film. The owner of the copyright in the documentary film is not, however, entitled to copyright protection for the specific facts contained in the film. The copyright holder could not prevent another from independently creating a documentary addressing the same topic or using the same historical facts, as long as the second author's expression is not substantially similar to the copyrightable expression in the first work.

Utilitarian works that do not contain any expression are not entitled to copyright protection. Such works, if entitled to protection at all, would more likely be protected by a patent than a copyright. If a work embodies both functional and separable expressive features, the expressive features may be copyrightable. For example, if a statue is used for the base of a lamp, the design of the statue may be copyrightable because it has a use outside of its use as the base of a lamp. A lamp base that would not be used for decorative purposes independent of its utilitarian use as a lamp base would not be entitled to copyright protection. As another example, the human readable expression embodied in a computer program (source code) is protectable under copyright, while the functional features of the program may be patentable.

Ownership of Copyright

Basic Principle

Ownership of a copyright in a work vests initially in "the author or authors of the work." Under current law federal copyright protection begins at the moment a work is fixed in tangible form. Before January 1, 1978, copyrightable works were protected by state common law as unpublished works prior to publication or registration. Federal copyright protection under the earlier statute began when the work was published with a copyright notice or when

an unpublished work was registered with the Copyright Office. Effective January 1, 1978, federal statutory protection preempted state common law protection.

Joint Works

If there is more than one author, the authors will be considered co-owners of the copyright. A work "prepared by two or more authors with the shared intention that their contributions be merged into inseparable or interdependent parts of a unitary whole" is called a "joint work." To be considered a co-owner, the coauthor must contribute original expression that could stand alone as copyrightable subject matter. For example, when a song is written, one author may compose the music and another the lyrics. So long as the authors intended their contributions to be merged into a single work, the two contributors are coauthors and, therefore, co-owners of the copyright of the song. Absent an agreement to the contrary, joint authors are deemed to own the work in equal, undivided shares.

Works Made for Hire

Ownership of copyright generally vests in the author (the creator) at the time the work is created. In certain instances, a work is a "work made for hire," and the copyright in the work is owned by an employer or some other person for whom a work was created. A "work for hire" is defined as a work either (1) prepared by an employee within the scope of the employment relationship or (2) specially ordered or commissioned for use as a contribution to a collective work, as part of a motion picture or other audiovisual work, as a translation, as a supplementary work, as a compilation, as an instructional text, as a test, as an answer material for a test, or as an atlas, if the parties expressly agree in a written instrument signed by them that the work shall be considered a work made for hire.

The Copyright Act provides that "[i]n the case of a work made for hire, the employer or other person for whom the work was prepared is considered the author" from the moment the work is created. Unless the employer and

employee have signed a written agreement to the contrary, the employer, as author, will own the copyright in the work. Whether an employment relationship exists may depend on a number of factors, including the degree of control by the hiring party over the manner and means of creating the work. If a work is specially ordered or commissioned, the creator, and not the commissioning party, is the author and owns the copyright provided that the work both falls within one of the specified categories and is subject to a written agreement between the parties.

Derivative Works

In some instances, an author may base a new work on a preexisting work. Such a work is called a "derivative work." The right to create, or authorize others to create, derivative works is one of the rights that belongs exclusively to the copyright owner. A derivative work is defined as a "work based upon one or more preexisting works, such as a translation, musical arrangement, dramatization, fictionalization, motion picture version, sound recording, art reproduction, abridgment, condensation, or any other form in which a work may be recast, transformed, or adapted." A derivative work borrows substantially from a preexisting work. In other words, the derivative work borrows enough from the preexisting work that if the preexisting work were under copyright protection and permission were not obtained from the author of the preexisting work, the new work would infringe on the prior copyright.

For a derivative work to have sufficient originality to qualify for copyright protection, the author of the derivative work must make more than a trivial contribution to the work. Examples of the type of contribution required include the following: "editorial revisions, annotation, elaborations, or other modifications which, as a whole, represent an original work of authorship."

The author of a derivative work or compilation will have a copyright interest only in those elements contributed by that author and only to the extent that the preexisting work has been used lawfully. The derivative author's copyright interest does not extend to the preexisting material used in the work. The copyright in the derivative work "does not affect or enlarge

the scope, duration, ownership, or subsistence of, any copyright protection in the preexisting material."

Compilations

A compilation is another type of work based on preexisting material. The Copyright Act defines a compilation as "a work formed by the collection and assembling of preexisting materials or of data that are selected, coordinated, or arranged in such a way that the resulting work as a whole constitutes an original work of authorship." A compilation differs from a derivative work in that a compilation does not involve any change to the underlying works, whereas a derivative work requires the underlying work to be recast, transformed, or adapted.

The copyright law treats compilations in a similar manner to derivative works. The copyright in a compilation extends only to the selection, coordination, and arrangement of the contents.

Rights of the Copyright Owner

The Copyright Act provides six categories of exclusive rights to the copyright owner. This means that only the copyright owner is permitted to exercise certain rights in the copyrighted work or authorize or license others to exercise these rights. The exclusive rights of the copyright owner are the rights (1) to reproduce the copyrighted work in copies or phonorecords; (2) to adapt the work (i.e., create a derivative work); (3) to distribute copies or phonorecords of the work to the public; (4) to perform certain categories of work publicly (literary, musical, dramatic and choreographic works, pantomimes, and motion pictures and other audiovisual works); (5) to display certain categories of work publicly (literary, musical, dramatic, and choreographic works, pantomimes, and pictorial, graphic, or sculptural works, and individual images of a motion pictures or other audiovisual works); and (6) to perform copyrighted sound recordings publicly by means of digital audio transmission.

By defining the rights that a copyright owner may exercise or authorize, the Copyright Act explicitly recognizes that there are certain uses that the copyright holder cannot prevent. In other words, uses that do not fall under the exclusive rights granted to a copyright holder cannot be prevented and do not infringe on the copyright.

Reproduction

The first, and most basic, right given to the owner of a copyright is the right "to reproduce the copyrighted work in copies or phonorecords." "Copies" are defined as "material objects, other than phonorecords, in which a work is fixed." "Phonorecords" are defined as "material objects in which sounds, other than those accompanying a motion picture or other audiovisual work, are fixed . . . and from which the sounds can be perceived, reproduced, or otherwise communicated, either directly or with the aid of a machine or device." In the case of architectural works, the right of reproduction includes the right to construct buildings based on the work.

Although there are certain exceptions, reproduction of copyrighted works without permission infringes on the copyright owner's exclusive rights. An infringement occurs even when the copies are not sold or publicly distributed, e.g., unauthorized downloading of a movie or song. Exceptions to this principle are limited to certain statutorily-defined circumstances and include the following: limited reproduction by libraries in circumstances outlined in the statute, reproduction of certain nondramatic literary works in formats for use by the blind and others with disabilities, copying of a computer program for maintenance or repair purposes, ephemeral copying of certain works under limited circumstances outlined in the statute, certain compulsory licenses, and other uses that are deemed fair uses under the law.

Adaptations/Derivative Works

The copyright owner also has an exclusive right of adaptation. In other words, the copyright owner has the exclusive right "to prepare derivative works based upon the copyrighted work." Derivative works, as previously

discussed, are new works based on preexisting works. Examples of derivative works are a film adaptation of a play or a new arrangement of a preexisting musical work.

Public Distribution

Another right given to the copyright owner by law is the right of public distribution. This right is the exclusive right of the copyright owner "to distribute copies or phonorecords of the copyrighted work to the public by sale or other transfer of ownership, or by rental, lease, or lending."

It is important to note that this right applies only to the first public distribution of a particular copy. Except for sound recordings and computer programs (copies of which may not be disposed of by "rental, lease, or lending"), the copyright owner gives up his or her right of distribution over any particular copy when that copy is given or sold to another party (note that digital works are generally licensed rather than sold, so this "first sale" doctrine does not apply because the license generally restricts further transfer and there was no sale). That is, once a person purchases a copy of a work, he or she is free to resell or to lend that particular copy to another. For example, a purchaser can resell a book to a used bookstore. The purchaser may not, however, make additional copies of the work.

Public Performance

For many works, the Copyright Act also grants copyright owners the exclusive right "to perform the copyrighted work publicly." According to the Copyright Act, "to 'perform' a work means to recite, render, play, dance, or act it." Such performance may be direct or with the use of devices or processes to show motion pictures or audiovisual works and to make their sounds audible.

To fall under the copyright owner's exclusive rights, the performance must be "public." The Copyright Act defines performing or displaying a work "publicly" as performing it at a place "open to the public" or at a gathering of a "substantial number of persons outside of a normal circle of a family and

its social acquaintances." The Copyright Act also defines public performance or display as communication of the work "by means of any device or process, whether the members of the public capable of receiving the performance or display receive it in the same place or in separate places and at the same time or at different times."

The right of performance is granted for literary, musical, dramatic, and choreographic works, pantomimes, and motion pictures and other audiovisual works. The right is not granted, however, for pictorial, graphic, and sculptural works, nor is it generally granted for sound recordings.

There are two distinct and separate copyrights embodied in a sound recording: (1) the underlying musical work created by a composer and a lyricist—the composition—and (2) the recording of a particular performance of that musical work by a musician. The sound recording has its own copyright, separate from the copyright in the musical composition. These two separate works may have the same or different owners and are entitled to different protection.

Thus, for a sound recording, only the owner of the copyright in the underlying musical composition (that is, the owner of copyright in the music and lyrics of a particular musical work) would be able to claim infringement for the unauthorized public performance of the copyrighted piece. The owner of the copyright in the sound recording (that is, the owners of copyright in the series of musical or other sounds embodied in the recording) does not have a claim for infringement of any performance right when the recording is played publicly, or "performed," without authorization. However, as outlined below, the owner of the copyright in the sound recording does have limited performance right and may have a claim for infringement of the right to perform those recordings by digital transmissions.

Display

The right to "display the copyrighted work publicly" is also granted to copyright owners by the Copyright Act. The right of display is granted for literary, musical, dramatic, and choreographic works; pantomimes; and pictorial, graphic, or sculptural works, including the individual images of motion pictures and other audiovisual works. The copyright in an architec-

tural work, however, does not give the owner a right to prevent the making, distribution, or public display of pictures of the work if the building is in a public place.

As defined by the Copyright Act, to "display" a work is to "show a copy of it, either directly or by means of a . . . device or process." The right of display applies only to displays that are "public." The act defines "publicly" in the same manner as previously discussed under performance rights.

There is an exception to the copyright owner's rights of both performance and display for certain charitable, religious, nonprofit, and educational purposes.

Digital Audio Transmission

The Copyright Act was amended in 1994 and 1998 to grant owners of a copyright in sound recordings the exclusive right to perform those recordings by digital transmissions (i.e., over the Internet). The scope of this exclusive right is limited to audio transmissions by digital means and is subject to a broad array of statutory limitations.

Visual Artists Rights Act

The Visual Artist Rights Act (VARA), passed in 1990, provides additional exclusive rights to authors of certain works of fine art—i.e., paintings, drawings, prints, sculptures, still photographic images produced for exhibition only, and existing in single copies or in limited editions of 200 or fewer copies, signed and numbered by the artist. VARA grants authors of the covered works a limited form of what are known as "moral rights." Moral rights protected by VARA include the right of attribution (i.e., the right to always be acknowledged as the author of a work and derivatives thereof) and the right of integrity (i.e., the right not to have a covered work distorted or modified without the author's consent). In the United States, this protection extends only to what might be considered works of fine art (as opposed to commercial art), i.e., paintings, drawings, prints, sculptures, still photographic images produced for exhibition only, and existing in single copies

or in limited editions of 200 or fewer copies, signed and numbered by the artist.

Statutory Right of Termination

With the shift in 1978 from what had been a two-term system of copyright protection to a single, much longer term of protection, the Copyright Act also added a new statutory right of termination. This right provides authors and their heirs the nonwaivable, unilateral right, during a five-year window, to terminate any grant of rights in a work simply by serving a notice of their intent to do so on the grantee or the grantee's successor in interest. This right provides a second bite of the apple for authors, a second chance after the value of a work has been established in the marketplace to recover rights previously transferred or to renegotiate the terms of transfer.

With respect to grants made after January 1, 1978, this five-year window opens 35 years from the date of execution of the grant or, if the grant covers the right of publication of the work, the sooner of 35 years from first publication or 40 years from the date of execution of the grant.

With respect to copyrights already secured before 1978, the five-year window opens at the end of 56 years from the date copyright was originally secured. A full explanation of the complexities of the exercise of this right is beyond the scope of this text and, accordingly, authors who may have works eligible for termination would be well advised to seek competent professional assistance. For more information about the termination right, see *Copyright Termination and Recapture Laws* by Marc H. Greenberg, published by the Intellectual Property Law Section of the American Bar Association.

Digital Millennium Copyright Act

In 1998, Congress passed the Digital Millennium Copyright Act (DMCA). The purpose of the DMCA was twofold. First, the DMCA implemented two treaties sponsored by the World International Intellectual Property Organization (WIPO), the WIPO Copyright Treaty and the WIPO Performances

and Phonograms Treaty. Second, the DMCA seeks to address some of the copyright issues that have emerged in the digital age.

Implementation of the WIPO Treaties

Several provisions of the DMCA implement the WIPO treaties and bring U.S. copyright law into harmony with the laws of WIPO member countries.

Restoration of Copyright Protection. The DMCA restores copyright protection to foreign works that may have fallen into the public domain in the United States because of failure to comply with U.S. formalities. A similar provision was part of the 1995 amendments to the Copyright Act. The DMCA extends this protection to works from additional foreign countries that may not have been covered by the 1995 amendments.

Exemption from Registration. American copyright law normally requires that a copyright be registered with the U.S. Copyright Office before the copyright owner can sue for infringement. The DMCA exempts all foreign works from this procedural requirement for access to the federal courts, but without a timely registration the enhanced remedies of statutory damages and recovery of attorneys' fees will not be available.

Protection of Copyrighted Works. The DMCA implements protection against circumvention of technological measures used by copyright owners to protect their works. The technological measures are categorized as measures that prevent unauthorized *access* to a work and those that prevent unauthorized *copying* of a work. Making or selling devices or services that circumvent technological measures in either category is generally prohibited. The DMCA also prohibits the act itself of circumventing a technological measure preventing unauthorized *access* to a copyrighted work. It does not, however, prohibit the act of circumventing a technological measure preventing unauthorized *copying*, since such copying may be considered a fair use under certain circumstances. Prohibited devices or services are those that (1) are primarily designed or produced to circumvent; (2) have only limited

commercially significant purpose or use other than to circumvent; or (3) are marketed for use in circumventing.

Certain organizations or activities are exempt from these prohibitions. For example, nonprofit libraries, archives, and educational institutions are exempt from the prohibition regarding access control measures if access is made solely to determine whether to obtain an authorized copy of the work. Law enforcement, intelligence, and other lawful government activities are exempt from the prohibitions. Persons engaged in reverse engineering for purposes of achieving interoperability of a computer program with other programs and those engaged in encryption research or security testing activities may circumvent access control measures if necessary to conduct those activities. The DMCA provides for an ongoing rule-making procedure that permits the Librarian of Congress, at the recommendation of the Register of Copyrights, to identify users who are adversely affected by the prohibitions on circumvention in making noninfringing uses of certain classes of works.

Copyright Management Information. A digital work may contain information relating to the owner of the copyright on that work. This information, known as "copyright management information" ("CMI") includes information identifying the work, including the title of the work, copyright owner, the author, performer, or director of the work, and terms and conditions for its use. The DMCA prohibits the intentional removal or alteration of this CMI or dissemination of works whose CMI has been removed or altered.

Unlike copyright infringement claims, claims under the DMCA for circumvention of technical protection measures or for removal or alteration of CMI do not require registration as a procedural step prior to suit. In either case, statutory damages and recovery of attorneys' fees may be available as enhanced remedies.

Additional Provisions of the DMCA

The DMCA also addresses issues relating to use of copyrighted material by online service providers and by users of computer software.

Online Service Providers

The DMCA provides a safe harbor and limits the liability of online service providers for certain activities under certain circumstances.

Conditions for Eligibility. To be eligible to take advantage of these safe harbors, an entity must be an "online service provider." "Online service providers" include entities that provide online services or network access or the operator of facilities for online services or network access. In certain circumstances, an "online service provider" may also include entities not directly involved in providing online services but that provide intermediary services such as transmitting, routing, or connecting online communications.

In addition, any online service provider that seeks protection under the DMCA safe harbors must not interfere with any technological measures used by copyright owners to identify and protect copyrighted works, must promptly take down content identified by the claimed owner in a properly served DMCA takedown notice, must implement a policy of terminating users of its services who repeatedly engage in copyright infringement, and must register with the Copyright Office a designated agent for receiving DMCA notices. The DMCA does not, however, require an online service provider to monitor its service for possible copyright infringement by its users.

Safe Harbors for Online Service Providers

The DMCA provides four safe harbors for activities by eligible online service providers. These providers can engage in the following activities with limited or no liability for copyright infringement.

Transitory Communications. The DMCA limits the liability of service providers where the provider merely transmits digital information from one point to another.

For a service provider to qualify for this safe harbor, the transmission must be initiated by someone other than the service provider and be carried out automatically without any affirmative action by the service provider. In

addition, the service provider must merely transmit the material without choosing the recipient of the transmission or modifying its content.

The DMCA also limits the liability of service providers for any copies of material such as copyrighted software code that are made during the operation of a network. To qualify for this portion of the safe harbor, any copies must be made automatically in the network, must not be accessible to unauthorized persons, and must not be retained any longer than reasonably necessary.

System Caching. The DMCA limits the liability of service providers for the practice of storing, or "caching," a copy of material that has been made available online, such as an Internet web page. Service providers commonly cache web pages so that when a user requests a web page, the service provider can quickly and efficiently transmit the easily accessible stored copy rather than having to retrieve the material from its original source.

To quality for this safe harbor, a service provider must not modify the content of the retained material, must refresh the retained material with a new copy in accordance with generally acceptable industry standards, and must not interfere with technology that returns "hit" information to the person who posted the material. In addition, the service provider must limit access to the material in accordance with the conditions for access (for example, a password) imposed by the person who originally posted the material. The service provider must also promptly remove or block any unauthorized copyrighted material from the stored copy upon receipt of notice that such unauthorized material has been removed from the original source.

Information Residing on Networks. The DMCA limits the liability of service providers who unknowingly post infringing material on websites or other information repositories hosted on their systems.

To qualify for this safe harbor, the service provider must not know of the infringement. In addition, the service provider must not receive any financial benefit from the infringement and must act quickly to remove the infringing material when it knows or becomes aware of its infringing nature.

Information Location Tools. The DMCA limits the liability of service providers for the act of referring or linking users, such as by a hyperlink,

an online directory, or a search engine, to a site that contains infringing material.

To qualify for this safe harbor, the service provider must not know of the infringement. In addition, the service provider must not receive any financial benefit from the infringement and must act quickly to remove the infringing material when it knows or becomes aware of its infringing nature.

Computer Maintenance or Repair

The DMCA also expanded the previously existing exemption in the Copyright Act relating to computer programs. Under previous law, the owner of a copy of a program may make additional copies or adaptations of the program when necessary to use the program on a computer. The DMCA permits the owner of a computer to make a copy of a computer program (or authorize a copy of the program to be made) in the course of maintaining or repairing that computer. The copy, however, must be one that is made automatically when the computer is activated, and the computer must already contain an authorized copy of the program. The new copy may be used only for purposes of maintenance or repair of the computer and must be destroyed immediately after the maintenance or repair is completed.

Miscellaneous Provisions

The DMCA also contains additional amendments to the Copyright Act. These include an exemption for libraries and archives to allow these organizations to take advantage of digital technologies when engaging in certain preservation activities. Other provisions further address the use of streaming audio technologies to make digital transmissions of sound recordings over the Internet and the making and use of ephemeral recordings permitted under the Digital Performance Right in Sound Recordings Act of 1995. For more information on how to make effective use of DMCA protections, see *DMCA Handbook: For Online Service Providers, Websites, and Copyright Owners*, Second Edition, by Connie J. Mableson, published by the Intellectual Property Law Section of the American Bar Association.

Duration of a Copyright

Works by Individual Authors—Life Plus 70 Years

The duration of copyright protection varies, depending on the date the work was created and the type of work. The copyright term for works created by individual authors after January 1, 1978, will subsist for a term beginning at the time of the work's creation and ending 70 years after the author's death. The same is generally true for unpublished works created before that date but not either copyrighted or in the public domain.

The time of the work's "creation" is when the work is first fixed in tangible form. All copyright terms run through December 31 of the appropriate anniversary year.

If it is not known whether the author is living or died less than 70 years earlier, the term of copyright extends for 95 years after the date the work was first published or, if earlier, 120 years after its creation. If an appropriate report from the Copyright Office is obtained, a user may rely on the presumption that the author of the work has been dead for at least 70 years and that the work is in the public domain (i.e., available for use without the permission of the author) as a defense to an action for copyright infringement.

Joint Works

Copyright in a joint work lasts for 70 years beyond the life of the last surviving coauthor.

Anonymous Works, Pseudonymous Works, and Works Made for Hire

Life of the author cannot always be used as a measuring device for duration of copyright because in certain types of works the author is unknown or is a business entity rather than a person. Therefore, when a work is anonymous, written under a pseudonym (pen name), or created in a work-for-hire

situation, the copyright will still last a fixed number of years. The copyright duration for such works, if created after January 1, 1978, is 95 years from the year of first publication or 120 years from the year of creation, whichever expires first.

If the identity of the author of an anonymous or pseudonymous work is revealed in Copyright Office records, then the duration of the copyright will be measured by the author's life plus 70 years. Any person having an interest in an anonymous or pseudonymous work may identify the author to the Copyright Office at any time.

Works Copyrighted before January 1, 1978

Works copyrighted before January 1, 1978, are protected for an initial term of 28 years and may be protected for a renewal term of 67 years, for a total term of protection of 95 years. Taking into account all of the changes over the last century in the term of copyright protection, there is no set of circumstances that could provide continuing protection for works first published more than 95 years ago. Because copyright protection ends on December 31 of the last anniversary year during which protection endures, on January 1 of each year going forward, a new year-class of older copyrighted works is injected into the public domain. For the year 2022, the works falling into the public domain on January 1 included those works first published during calendar year 1926. There may be later published works for which copyright protection has also lapsed because of a failure to timely renew or some other missed formality, but the only way to identify them is through a search of the Copyright Office records and perhaps also some additional research.

Statutory Formalities of Copyright

American copyright law traditionally required certain formalities as a prerequisite to copyright protection, such as use of a copyright notice on published copies of the work. Failure to comply with these formalities resulted in loss of copyright protection or loss of remedies for infringement. The

passage of the 1976 Act and the 1988 Berne Convention Implementation Act made formalities considerably less important.

Notice

When Notice Is Required. Until March 1, 1989, when the Berne Act was implemented, a copyright notice acted as a condition of copyright protection. Notice requirements were stringent and simple errors could result in loss of protection. The Berne Act eliminates the requirement of notice as a prerequisite for copyright protection of works first published without notice after February 1989; however, despite the Berne Act, the use of notice remains important.

Although works that lack a copyright notice are no longer thrust into the public domain, there remain incentives to affixing notice to copyrighted works. Existence of a copyright notice defeats a defendant's claim that statutory damages should be reduced because the infringement was innocent. Additionally, notice may deter potential infringers, make identification of legitimate copies easier, and protect information in the notice as "copyright management information."

Form of Notice. Generally, notice requires three elements: (1) the word "copyright," the symbol ©, or the abbreviation "copr."; (2) a designation of the copyright owner; and (3) the year of first publication. The notice for sound recordings is similar, except a symbol consisting of a "P" in a circle is substituted for the word "copyright."

Notice placed on copies of a copyrighted work must "be affixed to the copies in such manner and location as to give reasonable notice of the claim of copyright." This is a change from the prior Copyright Act of 1909, which had specific, required locations for placement of copyright notices. With respect to collective works, a single notice serves as proper notice of copyright for the separate contributions contained therein. A separate contribution to a collective work may, however, bear its own notice of copyright, and third-party advertisements included in collective works (such as periodicals) should always have separate copyright notices.

Registration

When Registration Is Required. A copyrighted work may be registered with the United States Copyright Office in Washington, D.C. Although copyright protection does not depend upon registration, registration secures a number of important benefits for copyright holders, especially in any subsequent infringement dispute.

For works first published in the United States (or in foreign countries not party to the Berne Convention or another international copyright treaty to which the United States is a party), registration generally is required before filing a copyright infringement suit. For works first published in treaty countries, registration is not required before bringing suit for infringement.

Although a work may be registered after an infringement has occurred, generally only copyright holders who have registered their works prior to infringement may recover statutory damages and attorneys' fees in court, regardless of where the work was first published. As will be noted later, registration also simplifies a copyright holder's burden of proof in pursuing an infringement claim. It is worth noting that registration is *not* a procedural requirement for actions to enforce rights under the Visual Artist's Rights Act or for access to enhanced remedies for violation of the anticircumvention provisions or the restrictions on removal or alteration of Copyright Management Information. For claims before the U.S. Copyright Claims Board, an application for registration of the work at issue must have been filed, and a registration must issue before the board can issue its decision.

Registration Procedure and Deposit. A protected work may be registered at any time during the copyright term. For works published prior to 1964, registration during the initial 28-year term was a condition to protection during the renewal term.

To register copyright in a work, the owner of copyright must complete and submit an application and a fee prescribed by the Copyright Office, together with one or more deposit copies of the work. Appropriate application forms for different categories of works are available free of charge from the Copyright Office and on its website (www.loc.gov/copyright/). They come with detailed instructions for completion and can generally be

completed by a layperson. Deposit requirements vary for different types of work.

After the proper application and accompanying materials are filed and the registration fee is paid, the Copyright Office examines the application and deposit to determine eligibility for registration. If the work contains sufficient originality and the application is completed properly, the copyright is formally registered. After registration the Copyright Office sends the applicant a certificate of registration, consisting of a copy of the application, an assigned registration number, the effective date of registration, and the seal and signature of the Register of Copyrights. If for any reason the Office determines that the work is not registrable or that the application is unacceptable, the applicant will be notified in writing and is entitled to respond as he or she deems appropriate.

Infringement

An infringement of a copyright occurs when someone "violates any of the exclusive rights of the copyright owner . . . or imports copies or phonorecords into the United States in violation of [the copyright owner's importation rights]." Infringement takes the form of unauthorized copying, adaptation, public distribution, performance, or display of a work. For example, an acting troupe that publicly performs a dramatic work without permission infringes the copyright owner's rights.

Proving Infringement

An infringement suit may be brought by any legal or beneficial owner of an exclusive right under a copyright. To prevail in an infringement suit, the plaintiff (person bringing the suit) must prove ownership of the copyright and copying or other violation of the plaintiff's exclusive rights by the defendant (person being accused). In the absence of direct evidence of copying, access to the copyrighted work and proof that the defendant's work is sub-

stantially similar to the protected work can be evidence of infringement. There is no requirement that the defendant intended to copy the plaintiff's work. This means that the plaintiff may be successful in an infringement suit even if the defendant copied the work accidentally or subconsciously, provided that the plaintiff can prove ownership, copying, and substantial similarity. However, independent creation does not constitute infringement. If a later author independently creates a work that is substantially similar to an existing work, there is no infringement if the later work was created without access or reference to the earlier work.

Ownership. The first part of the plaintiff's infringement case is proving ownership of the copyright. A registration certificate for the work, obtained within five years of the work's first publication, is presumed to prove ownership.

Copying and Other Unauthorized Uses

The next part of the plaintiff's case is to prove that the defendant copied the plaintiff's work or otherwise violated the plaintiff's exclusive rights as copyright owner. This could be proven through what is called "direct evidence." An example of direct evidence is a witness who observed the defendant copying the copyrighted work or otherwise violating the plaintiff's rights. Such witnesses are rarely available.

If direct evidence is unavailable, the plaintiff establishes this part of the case through what is called "indirect evidence." The indirect evidence usually consists of two parts: access and substantial similarity. The plaintiff must show that the defendant had access to the copyrighted work. If the work had been widely disseminated, the defendant may sometimes be presumed to have had access to the work even though he or she may deny any memory of it.

Next, the plaintiff must show that the defendant's work is "substantially similar" to protectable elements of the copyrighted work. To be substantially similar, the works need not be identical, but the similarities between them must be more than trivial. The legal standard for how close is too close is complex and varies from one federal circuit to another.

Vicarious Liability and Contributory Infringement

In certain instances, one person may be held liable for the infringing acts of another person. Vicarious liability may occur where Person A supervises or has the authority to supervise the infringing acts of Person B and Person A is in a position to financially benefit from the infringement. A computer software company may be held vicariously liable for copyright infringement by one of its employees, for example, incorporating copyrighted computer code into the company's own product, where that infringement benefited the company and the company had the authority to supervise the work of its employees, whether it exercised that authority or not.

Liability for contributory infringement may occur where Person A has encouraged or provided the means for the infringing acts of Person B, knowing the acts would constitute copyright infringement. For example, someone who arranges a "swap meet" where bootleg recordings are exchanged may be held liable for contributory infringement even if that individual did not actually make any of the infringed recordings. The copyright owner must also prove actual infringement by Person B.

Fair Use

Under certain circumstances, actions that would otherwise be considered copyright infringement are permitted as a "fair use" of the copyrighted work. Copyright law provides that the fair use of a copyrighted work, "including such use by reproduction in copies or phonorecords or by any other means . . . for purposes of criticism, comment, news reporting, teaching, scholarship, or research, is not an infringement of copyright."

Factors Considered in Determining if a Use Is a Fair Use

There is no one-size-fits-all definition for fair use. The Copyright Act lists four nonexclusive factors courts must consider in evaluating fair use defenses, but fair use is an "equitable" doctrine, requiring the court to

balance the arguments. The inquiry is fact-specific. That said, the Copyright Office has compiled a very useful database of fair use case summaries searchable and sortable on the basis of subject matter and Circuits and available at https://www.copyright.gov/fair-use/fair-index.html.

The Purpose and Character of the Use. The first factor that is considered in determining whether a use is fair is "the purpose and character of the use, including whether such use is of a commercial nature or is for nonprofit educational purposes." A nonprofit use generally will weigh more heavily for the defendant than a commercial use, but this does not necessarily mean that any noncommercial use will be deemed fair. The court will look at other factors, such as the motives of both sides, the public benefits of the use, and whether the use is transformative.

The Nature of the Copyrighted Work. The second factor is "the nature of the copyrighted work." Under this factor, a court weights the type of work used and whether it has been published by the copyright owner. Infringements of creative/inventive works are less likely to be protected as a fair use; unauthorized use of factual/nonfiction works is more likely to be protected. Works that have already been published are more likely to be protected than are works whose publication has not yet been authorized by the copyright owner.

The Amount and Substantiality of the Portion Used. The third factor is "the amount and substantiality of the portion used in relation to the copyrighted work as a whole." Under this factor, the court looks to see how much of the copyrighted work has been used, in both qualitative and quantitative terms. The larger or more significant the portion used, or the more substantial the excerpt used to the content of the copyrighted work, the less likely it is that the use is fair.

The Effect on the Market for or Value of the Copyrighted Work. The final factor to be considered is "the effect of the use upon the potential market for or value of the copyrighted work." Courts have frequently found this to be the most significant factor in fair-use analysis. The court looks at the use to see how it might affect the market for the copyrighted work. In addition, the court may look beyond the specific use before it and consider

how widespread conduct of the type engaged in by the defendant would affect the market for the copyrighted work. Note that potential harm is sufficient; actual harm is not required.

Remedies

A copyright owner who proves infringement is entitled to a variety of remedies.

Damages

The infringer will be liable to the copyright owner for damages. The copyright owner may recover actual damages (what the owner has lost as a result of the infringement) and, in addition, the owner may recover any profits of the infringer that are attributable to the infringement that are not taken into account when calculating actual damages.

Alternatively, if the work was timely registered, the copyright owner may elect to receive "statutory damages." Statutory damages may range from a minimum of $750 to as much as $30,000 for each work infringed (not each act of infringement). The maximum damages awarded can be raised to $150,000 if the plaintiff proves the infringement was willful; the minimum can be reduced to not less than $200 if the defendant proves the infringement was innocent.

Attorneys' Fees and Costs

The court may grant costs to either party. Reasonable attorneys' fees may be included as a portion of the costs for the prevailing party, if registration of the work was timely made. The award is discretionary; a court may elect to not award fees to a prevailing party, particularly if it finds the losing party's position was objectively reasonable.

Injunctions

The court has the power to grant injunctions if infringement is proven. Injunctive relief may be preliminary or permanent and can require the defendant to cease its use of infringing material. The availability of an injunction is subject to equitable considerations and may not be presumed; in other words, an injunction will not necessarily follow from a finding of infringement.

Impounding and Disposition of Infringing Articles

At any time during an infringement proceeding, the court has the authority to impound copies and phonorecords that are claimed to have been made or used in violation of the copyright owner's rights under copyright law. In addition, the court may impound any articles that may be used to reproduce copies or phonorecords.

As a part of its final judgment in an infringement action, the court has the authority to order the destruction of illicit copies and materials used to reproduce the copies.

Criminal Offenses

The copyright law provides for criminal penalties, as well as the civil penalties previously mentioned. An infringer may be subject to criminal penalties if the infringement is willful and "for purposes of commercial advantage or private financial gain."

The copyright law also provides criminal sanctions for other activities, such as placement of a fraudulent copyright notice on articles that are distributed publicly or imported for public distribution, fraudulent removal of a copyright notice, or false representation of a material fact during the copyright application process.

For more information about remedies, see *Copyright Remedies: A Litigator's Guide to Damages and Other Relief* by Eric M. Stahl and Henry J.

Tashman, published by the Intellectual Property Law Section of the American Bar Association.

The Copyright Alternative in Small-Claims Enforcement Act of 2020 (CASE Act)

Historically, copyright infringement claims were decided exclusively by the federal courts. But federal litigation is complex and expensive and for some copyright owners prosecuting infringement claims is economically unfeasible.

Congress responded to these concerns in 2020 by passing the CASE Act, which empowers the Copyright Office to establish a new tribunal, the Copyright Claims Board (CCB), to resolve copyright disputes with a monetary value of no more than $30,000. As of this writing, the Copyright Office is still establishing the procedural rules, processes, and forms that will guide the CCB. But the goal is to offer a cost-effective, streamlined, and voluntary alternative to litigation in federal courts, a process accessible to nonlawyers.

It is expected that this process will be complete by July of 2022. In the meantime, the Copyright Office will report progress and seek public comments and input at https://www.copyright.gov/about/small-claims.

About the Contributors

Stephen E. Gillen is a Cincinnati-based lawyer focusing his practice on publishing, media, and copyright matters. He currently serves as chair of the Books Board of the American Bar Association Section of Intellectual Property Law. A frequent author, speaker, and expert witness on copyright-related matters, he also has taught courses in Media Law as an adjunct professor at the University of Cincinnati.

David Rein is an attorney in the Golden, Colorado, and Kansas City offices of Avek IP, a boutique intellectual property law firm where he represents businesses and creative individuals throughout the country on how to obtain, license, and protect their intellectual property. He regularly litigates copyright cases involving publications, photographs, architectural works, and digital creations. He has served as the chair of several copyright committees of the American Bar Association Section of Intellectual Property Law, served as a co-chair of the Rocky Mountain Chapter of the Copyright Society of the USA, and teaches as an adjunct professor. He is a graduate of the University of Minnesota, obtained his J.D. from the University of Iowa, and is admitted to the Colorado, Kansas, and Missouri bars.

Eric M. Stahl is a partner in the Seattle and Los Angeles offices of Davis Wright Tremaine LLP, where he represents media, entertainment and communications companies nationwide in intellectual property, commercial, and First Amendment disputes. He regularly litigates offensive and defensive copyright and DMCA claims involving publications, motion pictures, photographs, music, and digital works. Mr. Stahl has served as chair of the Copyright Litigation Committee of the American Bar Association Section of Intellectual Property Law and as a National Trustee and Northwest chapter chair of the Copyright Society of the USA. He is a graduate of the University of Pennsylvania, obtained his J.D. from the University of Washington School of Law, and is admitted to the Washington State and California bars.

About the ABA Section of Intellectual Property Law

From its strength within the American Bar Association, the ABA Section of Intellectual Property Law (ABA-IPL) advances the development and improvement of intellectual property laws and their fair and just administration. The Section furthers the goals of its members by sharing knowledge and balanced insight on the full spectrum of intellectual property law and practice, including patents, trademarks, copyright, design, and trade secrets. Providing a forum for rich perspectives and reasoned commentary, ABA-IPL serves as the ABA voice of intellectual property law within the profession, before policy makers, and with the public.

ABA Section of Intellectual Property Law (ABA-IPL)
Order today! Call 800-285-2221
Monday-Friday, 8:00 a.m. – 5:00 p.m., CT
or visit www.ambar.org/iplbooks.

Qty	Title	Regular Price	ABA-IPL Member Price	Total
_____	ADR Advocacy, Strategies, and Practices for Intellectual Property and Technology Cases, 2nd Ed. (5370231)	$149.95	$119.95	$_____
_____	ANDA Litigation, 3rd Ed. (5370243)	$379.00	$295.95	$_____
_____	Antitrust Issues in Intellectual Property Law (5370222)	$149.95	$119.95	$_____
_____	Arbitrating Patent Disputes (5370229)	$89.95	$74.95	$_____
_____	Careers in IP Law (5370204) (The ebook is complimentary with ABA-IPL Section membership)	$24.95	$16.95	$_____
_____	Commercialization of IP Rights in China (5370241)	$119.95	$95.95	$_____
_____	Computer Games and Immersive Entertainment, 2nd Ed. (5370239)	$89.95	$69.95	$_____
_____	Copyright Litigation Strategies (5370228)	$369.00	$285.00	$_____
_____	Copyright Remedies (5370208)	$89.95	$74.95	$_____
_____	Copyright Termination Law (5370226)	$139.95	$109.95	$_____
_____	Crash Course on U.S. Patent Law (5370221)	$39.95	$34.95	$_____
_____	The DMCA Handbook, 2nd Ed. (5370234)	$79.95	$64.95	$_____
_____	The Essential Case Law Guide to PTAB Trials (5370233)	$249.95	$199.95	$_____
_____	The Essentials of Japanese Patent Prosecution (5370245)	$149.95	$119.95	$_____
_____	Intellectural Property and Technology Due Diligence (5370236)	$219.95	$179.95	$_____
_____	The Intellectual Property Law Handbook, 2nd Ed. (5620154)	$139.95	$109.95	$_____
_____	IP Attorney's Handbook for Insurance Coverage in Intellectual Property Disputes, 2nd Ed. (5370210)	$139.95	$129.95	$_____
_____	IP Protection in China (5370217)	$139.95	$109.95	$_____
_____	IP Strategies for Medical Device Technologies (5370238)	$149.95	$119.95	$_____
_____	IP Valuation for the Future (5370237)	$89.95	$59.95	$_____
_____	The Law of Trade Secret Litigation Under the Uniform Trade Secrets Act, 2nd Ed. (5370242)	$369.95	$295.95	$_____
_____	A Lawyer's Guide to Section 337 Investigations before the U.S. International Trade Commission, 4th Ed. (5370240)	$139.95	$109.95	$_____
_____	Legal Guide to Video Game Development, 2nd Ed. (5370227)	$74.95	$59.95	$_____
_____	A Legal Strategist's Guide to Trademark Trial and Appeal Board Practice, 4th Ed. (5370247)	$179.95	$144.95	$_____
_____	New Practitioner's Guide to Intellectual Property (5370198)	$89.95	$69.95	$_____
_____	Patent Freedom to Operate Searches, Opinions, Techniques, and Studies (5370230)	$139.95	$109.95	$_____
_____	Patent Neutral (5370232)	$89.95	$69.95	$_____
_____	Patent Trial Advocacy Casebook, 3rd Ed. (5370124)	$149.95	$119.95	$_____
_____	Patently Persuasive (5370206)	$129.95	$99.95	$_____
_____	The Practitioner's Guide to the PCT (5370205)	$139.95	$109.95	$_____
_____	The Practitioner's Guide to Trials Before the Patent Trial and Appeal Board, 2nd Ed. (5370225)	$159.95	$129.95	$_____

ABA Section of Intellectual Property Law (ABA-IPL)
Order today! Call 800-285-2221
Monday-Friday, 8:00 a.m. – 5:00 p.m., CT
or visit www.ambar.org/iplbooks.

Qty	Title	Regular Price	ABA-IPL Member Price	Total
_____	Pre-ANDA Litigation, 3rd Ed. (5370256)	$349.00	$259.00	$_____
_____	Preliminary Relief in Patent Infringement Disputes (5370194)	$119.95	$94.95	$_____
_____	Right of Publicity (5370215)	$89.95	$74.95	$_____
_____	Settlement of Patent Litigation and Disputes (5370192)	$179.95	$144.95	$_____
_____	Starting an IP Law Practice (5370202)	$54.95	$34.95	$_____
_____	Summary of Covenants Not to Compete (5370244)	$179.95	$144.95	$_____
_____	The Tech Contracts Handbook, 3rd Ed. (5370248)	$42.95	$33.95	$_____
_____	The Technology Transfer Law Handbook (5370211)	$220.00	$176.00	$_____
_____	Trademark and Deceptive Advertising Surveys, 2nd Ed. (5370255)	$189.95	$151.95	$_____
_____	What Is a Copyright (5370257)	$19.95	$16.95	$_____
_____	What Is a Trademark (5370250)	$19.95	$16.95	$_____

* Tax	$_____
** Shipping/Handling	$_____
TOTAL	$_____

* Tax
DC residents add 6%
IL residents add 10.25%
IN residents add 7%
CA residents add local sales tax
(between 6% and 10%)
FL residents add local sales tax
(between 6% and 8%)
GA residents add local sales tax
(between 4% and 9%)
MA residents add 6.25%
MD residents add 6%
MI residents add 6%
MN residents add local sales tax
(between 6.875% and 8.375%)
TX residents add local sales tax
(between 6.25% and 8.25%)
VA residents add local sales tax
(between 4.3% and 7%)
WA residents add local sales tax
(between 6.5% and 10.5%)
Tax includes applicable shipping costs
in IL, DC, CA, MI, MN, TX,
and WA.

**Shipping/Handling
Up to $49.99$8.95
$50 to $99.99..........................$10.95
$100 to $199.99$12.95
$200 to $499.99$15.95
$500 to $999.99$18.95
$1,000 and above3% of
order value

Payment
❏ Check payable to the ABA
❏ VISA ❏ Mastercard ❏ American Express ❏ Discover

Credit Card #_____ Exp._____

Signature_____

Name_____

Firm/Organization_____

Address_____

City_____ State_____ Zip Code_____

Phone_____ E-mail_____
(in case of questions about your order)

Please allow 5 to 7 business days for UPS delivery. Need it sooner? Ask about overnight delivery. Call the ABA Service Center at 800-285-2221 for more information.

Guarantee: If—for any reason—you are not satisfied with your purchase, you may return it within 30 days of receipt for a complete refund of the price of the book(s). No questions asked.

Please mail your order to:
ABA Publication Orders, 321 N. Clark St., 16th Floor, Chicago, Illinois 60654
Phone: 800-285-2221 or 312-988-5522 • Fax: 312-988-5568
E-mail: orders@abanet.org

Thank you for your order!

AMERICAN**BAR**ASSOCIATION
Intellectual Property
Law Section